The Power of a Woman

The Power
of a Woman

Selected and with
an Introduction
by
Janet Mills

The Classic Wisdom Collection
New World Library
San Rafael, California

The Classic Wisdom Collection
Published by New World Library
58 Paul Drive, San Rafael, CA 94903

Cover design: Greg Wittrock
Text design: Nancy Benedict
Typography: TBH Typecast, Inc.

Cover painting: Detail from "The Marquise de Pezé and the Marquise de Rouget with Her Two Children" by Elisabeth Vigée-Lebrun, 18th century. National Gallery, Washington, D.C.

Library of Congress Cataloging-in-Publication Data

The Power of a woman / selected and with an introduction by Janet Mills.
 p. cm. — (The Classic wisdom collection)
 Includes bibliographical references and index.
 ISBN 1-880032-39-2 : $12.95
 1. Women — Quotations. 2. Quotations, English.
 I. Mills, Janet. II. Series.
PN6081.5.P69 1994
808.88'2 — dc20
 93-45653
 CIP

ISBN 1-880032-39-2

Printed in the U.S.A. on acid-free paper
Distributed by Publishers Group West

10 9 8 7 6 5 4 3 2 1

A wise man once said:
"Never underestimate
the power of a woman."

To Deepak Chopra, M.D.,
whose spirit and power
have strengthened my own.

Contents

CONTENTS

Part Three The Power of Action

Publisher's Preface

Life is an endless cycle of change. We and our world will never remain the same.

Every generation has difficulty relating to the previous generation; even the language changes. The child speaks a different language than the parent.

It seems almost miraculous, then, that certain voices, certain books, are able to speak to not only one, but many generations beyond them. The plays and poems of William Shakespeare are still relevant today — still capable of giving us goose bumps, still entertaining, disturbing, and profound. Shakespeare is the writer who, in the English language, defines the word *classic*.

There are many other writers and thinkers who, for a great many reasons, can be considered classic, for they withstand the test of time. We want to present the best of them to you in the New World Library Classic Wisdom Collection, the thinkers who are still relevant and important

in today's world for the enduring words of wisdom they created, words that should forever be kept in print.

The Power of a Woman is a special book in this collection, an eclectic gathering of the writings of women from diverse cultures, past and present. We are proud to present this tribute to the wisdom and power of women.

Marc Allen
New World Library

Introduction

The power of a woman lies within her heart, within her capacity to touch others with her love, and within the quiet resources of her soul.

The power of a woman — just *one* woman — can lighten the burden of one who is suffering or stir the hearts of millions and change the world. Just one woman can make a difference when she believes in her god-given powers and makes an effort to use them.

Within each woman is the power to give joy to others, to live her dreams, and to love with all her heart. This kind of power kindles hope, inspires faith, and keeps the spirit alive within all of us. The power of a woman is not power *over* anyone, but rather power to move her life in the direction of her dreams, in alignment with who she is at the core of her existence.

The power of a woman is her inner strength and character, and the sum of who she is as an individual; it is her values and the ways in which

she expresses those values. It is also in the way she perceives herself in the world; how she carries herself, responds to others, and conducts her life. Others will always be drawn to the woman who is certain of who she is, who is unafraid to freely express her true nature. This is the power of a woman.

The longer I live, the more I am convinced that it is the false belief in *powerlessness* that causes so much suffering. If a woman cannot trust her power or act on it, she is severely limited in what she is able to create and experience. For it is only by accepting and honoring her character and true self that she not only discovers her inner strengths, but develops and increases them with each use.

It is by leading an empowered life that a woman is able to feel and express her gratitude and reverence for life. And her joy in the experience of living is magnified many times over.

To lead an empowered life, a woman must embrace her power — all the power she needs to create her life and fulfill her destiny as she sees fit. She must not allow her power to be dissipated through fear, jealousy, needless worry,

confusion, and inability to make a decision. And she must take back the power she gives to self-limiting, self-defeating beliefs, the power she gives to men, and the power she gives to government, marriage, and other institutions that limited her freedom in the past.

A woman must call upon all her energy in order to move her experience of life into new dimensions of creativity and freedom. She has not only physical power, but mind power, not only mind power, but emotional power to move creation and inspire it. And, without doubt, she has spiritual power, which is closest to her god-like nature and is capable of creating everything her heart desires.

There is power in her strong mind, her healthy body, and her heart — free of unjustified fear. There is power in the education of her mind, the discipline of her thoughts, in her clear and direct communication, and her firm handshake. There is power in her words, not merely those spoken to others, but the sounds of words within her mind and body. There is power in her clear intention and in a willingness to commit her life to whatever she believes in. But the

greatest powers of all are Love, Faith, and Action. All things are possible with these powers.

In these pages, generations of women have spoken their minds. Many have braved new horizons and paved the way for succeeding generations to follow. Their wisdom and power has made a difference in the lives of many, for each soul that lifts itself out of darkness into the light of Love, Faith, and Action makes it easier for others to follow. The whole world becomes a brighter place. And that is why the power of *one* woman's voice, one moment of joy, or one simple act of love can make a difference.

This book is a tribute to that power within you: the power of your Love, Faith, and Action.

Janet Mills
San Rafael, California, 1994

Editor's Note

The excerpts in the text are followed by the author names; for fictional entries, book titles are also added. Chapter opening quotes are the contributions of the editor. Information on eighty women contributors is found in the alphabetical bibliographic index at the end of the book.

Part One

The Power of Love

GODDESS OF LOVE

I am a Goddess of Light, Love, and Song
powerful and strong,
yet soft as a whisper in the wind.

I am a Goddess in this worldly domain
sent on a mission
to explore the possibilities of Love.

I am a Goddess forever in Love
with the laughter of children
and the moon's shining face.

So I'll sing a Song of Light and Love
and awaken the souls of those sleeping.

I am a Goddess without time for folly.
I have dreams to weave
into patterns for my loved ones
and faces to light with my smile.

1

Love

Within the smallest grain of sand there is love, joy, history, romance, and hope . . . eternal life, in changing form. . . . It is Love in all of its manifestations, holding form together, bonding our souls to this earth and to one another.

Love is a fruit in season at all times, and within reach of every hand.

MOTHER TERESA

Love has unequaled power, because love is the power that unifies the whole world and everything in it . . . the law of gravity is love in action. Love is the equalizing, harmonizing, balancing,

3

adjusting force that is ever at work throughout the universe. Working in these ways, love can do for you what you cannot humanly do for yourself.

CATHERINE PONDER

Love is something like the clouds that were in the sky before the sun came out. You cannot touch the clouds, you know; but you feel the rain and know how glad the flowers and the thirsty earth are to have it after a hot day. You cannot touch love either; but you feel the sweetness that it pours into everything.

ANNIE SULLIVAN

Where love is absent, there can be no woman.

GEORGE SAND

Love is the intuitive knowledge of our hearts. It's a "world beyond" that we all secretly long for. An ancient memory of this love haunts all of us all the time, and beckons us to return.

MARIANNE WILLIAMSON

Lakota children had an opportunity to begin early in life to attend to the whole or the holiness, the spiritual side of things, and then to expand this ability powerfully as they grew. We, too, can acknowledge that Spirit lives within us, that we are a part of God. The more we can love ourselves and attend to all of life around us with a loving, open, connected heart and good relationship, the more we can be in a very beautiful place. All it takes is practice.

BROOKE MEDICINE EAGLE

Anne has so many shades as a rainbow and every shade is the prettiest while it lasts. . . . She makes me love her and I like people who make me love them. It saves me so much trouble in making myself love them.

L. M. MONTGOMERY
Anne of Green Gables

There is no power on earth that can withstand the power of love. By loving our enemies we turn them into friends.

STELLA TERRILL MANN

Love is a force. It is not a result; it is a cause. It is not a product; it produces. It is a power, like money, or steam or electricity. It is valueless unless you can give something else by means of it.

<div align="right">ANNE MORROW LINDBERGH</div>

Before you can express love, you must find love. You must know love within yourself before you can express it. You must love yourself before you can give it to others. When you recognize or experience the truth about yourself you automatically feel love, because love is a quality of your true consciousness and true ideas.

<div align="right">TAE YUN KIM</div>

The measure of my happiness is not how much I feel loved by the man in my life, but how much I am willing to love life and *be* "love," to see and feel the miracle of life all around me, and to know that I am one with the Power that gives life.

<div align="right">ANONYMOUS</div>

Her world was bordered on all sides with work, duty, religion and "her place." I don't think she

ever knew that a deep-brooding love hung over everything she touched. (speaking about her mother)

MAYA ANGELOU

Perhaps telepathy will remain a mystery for many more years, but it has always been within the power of a few people in every generation to transmit and receive thoughts. People in love often claim this power. Maybe we are being forced to realize that love is in itself a magical power and that awareness may be instrumental in preventing our own destruction.

SYBIL LEEK

Love, I find is like singing. Everybody can do enough to satisfy themselves, though it may not impress the neighbors as being very much.

ZORA NEALE HURSTON

If we want a joyous life, we must think joyous thoughts. If we want a prosperous life, we must think prosperous thoughts. If we want a loving life, we must think loving thoughts. *Whatever we*

send out mentally or verbally will come back to us in like form.

<div align="right">LOUISE L. HAY</div>

Tita knew through her own flesh how fire transforms the elements, how a lump of corn flour is changed into a tortilla, how a soul that hasn't been warmed by the fire of love is lifeless, like a useless ball of corn flour.

<div align="right">

LAURA ESQUIVEL
Like Water for Chocolate

</div>

Loving can cost a lot but not loving always costs more, and those who fear to love often find that want of love is an emptiness that robs the joy from life. . . .

<div align="right">MERLE SHAIN</div>

She tried to recall the cold, the silence, and that precious feeling of owning the world, of being twenty years old and having her whole life ahead of her, of making love slowly and calmly, drunk with the scent of the forest and their love, without a past, without suspecting the future,

<div align="center">8</div>

with just the incredible richness of that present moment in which they stared at each other, smelled each other, kissed each other, and explored each other's bodies, wrapped in the whisper of the wind among the trees and the sound of the nearby waves breaking against the rocks at the foot of the cliff, exploding in a crash of pungent surf, and the two of them embracing underneath a single poncho like Siamese twins, laughing and swearing that this would last forever, that they were the only ones in the whole world who had discovered love.

ISABEL ALLENDE
The House of the Spirits

Truth, Life, and Love are formidable, wherever thought, felt, spoken, or written. . . . They are the victors never to be vanquished. Love is the generic term for God.

MARY BAKER EDDY

The moment you judge, you stop loving and you separate yourself from God.

ANONYMOUS

All that is necessary to make this world a better place to live is to love — to love as Christ loved, as Buddha loved.

ISADORA DUNCAN

Love is the only thing that we can carry with us when we go, and it makes the end so easy.

LOUISA MAY ALCOTT

2

Self-Esteem
& Self-Reverence

Without self-love there is little we can give to others, for whatever we withhold from ourselves, we withhold from others.

I find that when we really love and accept and *approve of ourselves exactly as we are*, then everything in life works. It's as if little miracles are everywhere. Our health improves, we attract more money, our relationships become much more fulfilling, and we begin to express ourselves in creatively fulfilling ways. All this seems to happen without our even trying.

LOUISE L. HAY

It is healthier to see the good points of others than to analyze our own bad ones.

FRANÇOISE SAGAN

I asked myself, What is true about a person? Would I change in the same way the river changes color but still be the same person? And then I saw the curtains blowing wildly, and outside rain was falling harder, causing everyone to scurry and shout. I smiled. And then I realized it was the first time I could see the power of the wind. I couldn't see the wind itself, but I could see it carried the water that filled the rivers and shaped the countryside. It caused men to yelp and dance.

I wiped my eyes and looked in the mirror. I was surprised at what I saw. I had on a beautiful red dress, but what I saw was even more valuable. I was strong. I was pure. I had genuine thoughts inside that no one could see, that no one could ever take away from me. I was like the wind.

AMY TAN
The Joy Luck Club

To have the sense of one's own intrinsic worth which constitutes self-respect is potentially to have everything: the ability to discriminate, to love and to remain indifferent. To lack it is to be locked within oneself, paradoxically incapable of either love or indifference.

JOAN DIDION

This conviction of being loved and lovable, valued and valuable *as we are*, regardless of what we do, is the beginning of the most fundamental kind of self-esteem: what psychologists call "global" or "characterological" or (the term I find most descriptive because it connotes something that comes first) "core" self-esteem.

GLORIA STEINEM

No one can make you feel inferior without your consent.

ELEANOR ROOSEVELT

Humility is not my forte, and whenever I dwell for any length of time on my own shortcomings, they gradually begin to seem mild, harmless,

rather engaging little things, not at all like the startling defects in other people's characters.

MARGARET HALSEY

Unconditional love is something that arises naturally when we can accept all our feelings and love all parts of us, including the parts that aren't unconditionally loving.

SHAKTI GAWAIN

There is no "supposed to be" in bodies. The question is not size of shape or years of age, or even having two of everything, for some do not. But the wild issue is, does this body feel, does it have right connection to pleasure, to heart, to soul, to the wild? Does it have happiness, joy? Can it in its own way move, dance, jiggle, sway, thrust? Nothing else matters.

CLARISSA PINKOLA ESTÉS

I seldom think about my limitations, and they never make me sad. Perhaps there is just a touch

of yearning at times; but it is vague, like a breeze among flowers.

HELEN KELLER

We are so many selves. It's not just the long-ago child within us who needs tenderness and inclusion, but the person we were last year, wanted to be yesterday, tried to become in one job or in one winter, in one love affair or in one house where even now, we can close our eyes and smell the rooms. What brings together these ever-shifting selves of infinite reactions and returnings is this: There is always one true inner voice. Trust it.

GLORIA STEINEM

Imagine the joy of day by day growing into a fuller understanding of who you are — who you are, really, the power you really have. It's this simple: your real self awaits your knowing. Let it come slowly, like the dawn, if it must.

TAE YUN KIM

3

Character
& Inner Strength

Our life experiences are a reflection of who we are. We cannot stop ourselves from thinking and creating any more than we can stop the wind from blowing. But we can become a more conscious creator . . . through our desire and decision to do so, and with the power of our love.

A healthy woman is much like a wolf; robust, chock-full, strong life force, life-giving, territorially aware, inventive, loyal, roving. Yet separation from the wildish nature causes a woman's personality to become meager, thin, ghosty,

spectral. We are not meant to be puny with frail hair and inability to leap up, inability to chase, to birth, to create a life. When women's lives are in stasis, ennui, it is always time for the wildish woman to emerge; it is time for the creating function of the psyche to flood the delta.

CLARISSA PINKOLA ESTÉS

Achievement doesn't come from what we do, but from who we are. Our worldly power results from our personal power.

MARIANNE WILLIAMSON

Everything nourishes what is strong already.

JANE AUSTEN

One is happy as a result of one's own efforts, once one knows the necessary ingredients of happiness — simple tastes, a certain degree of courage, self denial to a point, love of work, and above all, a clear conscience. Happiness is no vague dream, of that I now feel certain.

GEORGE SAND

Parents can only give good advice or put them on the right paths, but the final forming of a person's character lies in their own hands.

ANNE FRANK

Being powerful is like being a lady. If you have to tell people you are, you aren't.

MARGARET THATCHER

Truly great people emit a light that warms the hearts of those around them.

BANANA YOSHIMOTO
Kitchen

"That man's jaws are loaded with big words, but he never says a thing," she said, speaking of a mutual friend. "He got his words out of a book. I got mine out of life."

ZORA NEALE HURSTON
Dust Tracks on a Road

I've always believed that because I was blessed enough to be healthy and have a strong, sup-

portive family, I had an obligation to care for other people, to help them. It wasn't something you did as an afterthought. It was how you lived.

HILLARY RODHAM CLINTON

If you had beauty everywhere, you would have people who have mellow spirits. I have been in ghettos, and I thank goodness I never lived in one, because even though I had to live in shacks, they were in the middle of the most incredible splendor. So I never confused myself with the poverty. I always identified with the grandeur, the beauty.

ALICE WALKER

Only on the surface of things have I ever trod the beaten path. So long as I could keep from hurting anyone else, I have lived, as completely as it was possible, the life of my choice.

ELLEN GLASGOW

"I know that I am a slave, and you are my lord. The law of this country has made you my master. You can bind my body, tie my hands, govern my

actions: you are the strongest, and society adds to your power; but with my will, sir, you can do nothing. God alone can restrain it and curb it. Seek then a law, a dungeon, an instrument of torture, by which you can hold it; it is as if you wished to grasp the air, and seize vacancy."

GEORGE SAND

You must learn to be still in the midst of activity and to be vibrantly alive in repose.

INDIRA GANDHI

Sublime is the dominion of the mind over the body, that for a time can make flesh and nerve impregnable, and string the sinews like steel, so that the weak become so mighty.

HARRIET BEECHER STOWE

My mother told me a long time ago that a woman should never tell a man the whole truth. She said some things you keep to yourself, because they'll use it against you later. She said a woman should never tell a man how many times she's been in love, how many men she's slept with,

and under no circumstances should you give him any details about your past relationships.

TERRY MCMILLAN
Waiting to Exhale

So many mirrors in the house, upstairs and down. But none shows her true face.

JOYCE CAROL OATES
Where Is Here?

Your thoughts blossom into events. If you think the world is evil, you will meet with events that seem evil. There are no accidents in cosmic terms, or in terms of the world as you know it. Your beliefs grow as surely in time and space as flowers do. When you realize this you can even feel their growing.

JANE ROBERTS

Part Two

The Power of Faith

I have seen what I must do in a moment's inspiration. . . .

I will travel to the dark continent of Africa where I will lie in the soft sands of the desert and ride through a moonlit night on the top of a train with my lover . . .

. . . and I will dance with the native tribes of Africa around a fire of creation and sing their chants until I am drunk with laughter.

Then I will travel to India where I will sit with the wise ones until I remember who I am . . . until my skin is aglow with the radiant light of memory rekindled and wisdom unleashed at last.

And then I will travel to South America
where I will run naked
through a tropical rainforest . . .
gratefully feeling the rain wash away
all the sadness of my life . . .

. . . and I will play with the native animals
of the forest and learn what they have to
teach me in their wild, abandoned calls.

And when I return from my travels,
filled with the energy of kindred spirits
and the knowledge of my true power,
I will joyfully and gratefully receive my desires
. . . simply because I willed them into being
and summoned uncommon courage
to petition the Gods.

And I will know the true joy of freedom,
the true magic of creation without effort,
the wondrous power of my word,
and the sweetest knowledge of my faith.

4

Faith

We develop faith by knowing that all things are interrelated and all are formed of intelligent god-stuff that responds to conscious thought. Beyond our fears, beyond our doubts, there is light and endless love to guide us. When all else changes, this remains our constant.

The fruit of prayer is a deepening of faith and the fruit of faith is love.

MOTHER TERESA

As time went on my thoughtless optimism was transmuted into that deeper faith that weighs the ugly facts of the world, yet hopes for better things

and keeps on working for them even in the face of defeat.

HELEN KELLER

Faith is an excitement and an enthusiasm: it is a condition of intellectual magnificence to which we must cling as to a treasure, and not squander on our way through life in the small coin of empty words, or in exact and priggish argument. . . .

GEORGE SAND

Truth never falters or fails; it is our faith that fails.

MARY BAKER EDDY

The especial genius of women, I believe to be electrical in movement, intuitive in function, spiritual in tendency.

MARGARET FULLER

Faith is believing without seeing. . . . To use faith we must believe we shall receive without understanding or without the feeling that we must understand the who, what, why, when, where

or how we are to receive the desire of our heart. For the instant we start to try to understand it all, to bring things to pass of our own efforts, that instant we have left faith and taken up either doubt or fear.

STELLA TERRILL MANN

Faith and doubt both are needed — not as antagonists, but working side by side — to take us around the unknown curve.

LILLIAN SMITH

Nature has created us with the capacity to know God, to experience God.

ALICE WALKER

To trust in the force that moves the universe is faith. Faith isn't blind, it's visionary. Faith is believing that the universe is on our side, and that the universe knows what it's doing. Faith is a psychological awareness of an unfolding force for good, constantly at work in all dimensions.

MARIANNE WILLIAMSON

It was a curious thing that I myself did not, during this time, ever believe that I would have to give up the farm or to leave Africa. . . . For this firm faith I had no other foundation, or no other reason, than my complex incompetency of imagining anything else.

ISAK DINESEN
Out of Africa

Today my soul can only sing and soar. An increasing sense of God's love, omnipresence, and omnipotence enfolds me.

MARY BAKER EDDY

There is no order of difficulty in miracles. One is not "harder" or "bigger" than another. They are all the same.

A Course in Miracles

Faith is not having to have constant proof.

JO-ANNE J. AUSTIN

Bromidic though it may sound, some questions *don't* have answers, which is a terribly difficult lesson to learn.

KATHERINE GRAHAM

It is this belief in a power larger than myself and other than myself which allows me to venture into the unknown and even the unknowable. . . .

MAYA ANGELOU

Nothing increases our faith more than that of accomplishment. . . . A power once used successfully will do more for your faith than all the books you can ever read.

STELLA TERRILL MANN

Death is not an escape from the pain and sorrow of living. Wisdom, faith, and love are.

ANONYMOUS

5

Patience & Humor

Patience is a quiet strength that seems to develop over time as a partner of wisdom. . . . It speaks to us of the truth that all things we desire will unfold in their own way, in their own time.

The sea does not reward those who are too anxious, too greedy, or too impatient. To dig for treasures shows not only impatience and greed, but lack of faith. Patience, patience, patience, is what the sea teaches. Patience and faith. One should lie empty, open, choiceless as a beach — waiting for a gift from the sea.

ANNE MORROW LINDBERGH

She was someone who could not be rushed. This
seems a small thing. But it is actually a very
amazing quality, a very ancient one. . . . She
went about her business as if she would live for-
ever, and forever was very, very long . . . but I
have lost "forever"; therefore I sometimes hurry.

ALICE WALKER
The Temple of My Familiar

To be wildly enthusiastic, or deadly serious —
both are wrong. Both pass. One must keep ever
present a sense of humor.

KATHERINE MANSFIELD

In the life of the mind, glad or sad, there will
always be laughter, and the life of the mind
alone, I have found, contains an antidote to
experience. . . .

ELLEN GLASGOW

It is imperative that a woman keep her sense
of humor intact and at the ready. . . . It has been
said that laughter is therapeutic and amiability

lengthens the life span. Women should be tough, tender, laugh as much as possible, and live long lives.

MAYA ANGELOU

I'm extraordinarily patient provided I get my own way in the end.

MARGARET THATCHER

A boy can run and chase dragonflies, because that is his nature, she said. But a girl should stand still. If you are still for a very long time, a dragonfly will no longer see you. Then it will come to you and hide in the comfort of your shadow.

AMY TAN
The Joy Luck Club

One of nature's most beautiful symbols of patience is the transformation — the metamorphosis — of the caterpillar into a butterfly. . . . A transformation occurs in the quiet cocoon that cannot be rushed or disturbed. . . . The laws of manifestation that govern our being are just as

absolute. We likewise must have the patience and trust to let them work. True patience is knowing the truth and expecting the truth to manifest. . . . You keep the power turned on as you wait knowingly for the manifestation to appear at its appointed time.

TAE YUN KIM

But she had, as I have told you, the glimmerings of a sense of humor — which is simply another name for a sense of the fitness of things. . . .

L. M. MONTGOMERY
Anne of Green Gables

We could never learn to be brave and patient, if there were only joy in the world.

HELEN KELLER

When we begin to take our failures nonseriously, it means we are ceasing to be afraid of them. It is of immense importance to learn to laugh at ourselves.

KATHERINE MANSFIELD

Those who do not know how to weep with their whole heart don't know how to laugh either.

GOLDA MEIR

Humor bypasses the need for strict and rigid spiritual practices. A day spent laughing will bring us closer to God than a day of heavy soul-searching. This is because laughter brings us closer to the real us — the lovable us, the happy us, the free us, the us others want to be around. Laughing frees our creativity. . . . No need to push the river. Just build a raft, hop on it, and burst out laughing at the bends and rapids along the way.

TERRY LYNN TAYLOR

6

Courage
& Self-Confidence

Courage is faith in action . . . it is a power that
speaks quietly for itself, never boasting of its
strength, for in doing so it would lose its power.

Courage is the price that life exacts for granting
peace. The soul that knows it not, knows no re-
lease from little things; knows not the livid lone-
liness of fear.

AMELIA EARHART

You gain strength, courage, and confidence by
every experience in which you really stop to look

fear in the face. . . . You must do the thing which you think you cannot do.

ELEANOR ROOSEVELT

It isn't that some people are more gifted or more chosen than others . . . all people are called and all people are chosen; but few really have the courage to follow their dreams and to follow power when it presents itself. What we need is the courage to see that everything around us in our lives is a mirror of God. We can choose to look in the mirror or to look away.

LYNN ANDREWS

We discovered that peace at any price is no peace at all. . . . We discovered that life at any price has no value whatever; that life is nothing without the privileges, the prides, the rights, the joys which make it worth living, and also worth giving. And we also discovered that there is something more hideous, more atrocious than war or than death: and that is to live in fear.

ÉVE CURIE

Most of man's problems upon this planet, in the long history of the race, have been met and solved either partially or as a whole by experiment based on common sense and carried out with courage.

FRANCES PERKINS

But when Alice closes her eyes she sees, at the moment Mason jars. She knows that no woman with varicose veins and a brain in her head would walk away from a decent husband, but she's going to anyway.

BARBARA KINGSOLVER
Pigs in Heaven

Everyone has talent. What is rare is the courage to follow the talent to the dark place where it leads.

ERICA JONG

Even the most repressed woman has a secret life, with secret thoughts and secret feelings which are lush and wild, that is, natural. Even the most

captured woman guards the place of the wild-
ish self, for she knows intuitively that someday
there will be a loophole, an aperture, a chance,
and she will hightail it to escape.

CLARISSA PINKOLA ESTÉS

Among all the forms of absurd courage, the
courage of girls is outstanding. Otherwise there
would be fewer marriages. . . .

COLETTE

Security is mostly a superstition. It does not exist
in nature, nor do the children of men as a whole
experience it. Avoiding danger is no safer in the
long run than outright exposure. Life is either a
daring adventure or nothing.

HELEN KELLER

Nothing in life is to be feared. It is only to be
understood.

MARIE CURIE

There is no such thing as security. There never
has been. . . . Although security is not in the na-

ture of things, we invent strategies for outwitting fortune, and call them after their guiding deity — insurance, assurance, social security. Security is when everything is settled; when nothing can happen to you; security is the denial of life. Human beings are better equipped to cope with disaster and hardship than they are with unvarying security, but as long as security is the highest value in a community they can have little opportunity to decide this for themselves.

GERMAINE GREER

I will not shrink from undertaking what seems wise and good because I labor under the double handicap of race and sex, but, striving to preserve a calm mind with a courageous and cheerful spirit, barring bitterness from my heart, I will struggle all the more earnestly to reach the goal.

MARY CHURCH TERRELL

I have met brave women who are exploring the outer edge of human possibility, with no history to guide them, and with a courage to make themselves vulnerable that I find moving beyond words.

GLORIA STEINEM

If I had my life to live over again, I'd dare to make more mistakes next time. . . . I would take more chances. I would climb more mountains and swim more rivers. . . . I would perhaps have more actual troubles, but I'd have fewer imaginary ones.

NADINE STAIR

I thought that the chief thing to be done in order to equal boys was to be learned and courageous. So I decided to study Greek and learn to manage a horse.

ELIZABETH CADY STANTON

Everything is so dangerous that nothing is really very frightening.

GERTRUDE STEIN

To be completely unafraid of feeling betrayed, abandoned, unloved, or deep sorrow is to be free . . . free to feel vulnerable and free to be foolishly joyful . . . for whatever the future brings, there is no emotion that need be feared.

ANONYMOUS

Whenever I have to choose between two evils, I always like to try the one I haven't tried before.

MAE WEST

It is worth taking the leap for something you have always wanted to do because until you try you'll never know. Through the experiences I have had and the risks I have taken, I have gained courage and confidence. I didn't start with the courage and confidence. I started with the risk.

LAURA DAVIS

Life, as it is, does not frighten me, since I have made my peace with the universe as I find it, and bow to its laws. I know that nothing is destructible; things merely change forms. When the consciousness we know as life ceases, I know that I shall still be part and parcel of the world. I was a part before the sun rolled into shape and burst forth in the glory of change. I was, when the earth was hurled out from its fiery rim. I shall return with the earth to Father Sun, and still exist in substance when the sun has lost its fire, and

disintegrated in infinity to perhaps become a part of the whirling rubble in space. Why fear? The stuff of my being is matter, ever changing, ever moving, but never lost. . . . I am one with the infinite and need no other assurance.

ZORA NEALE HURSTON

Part Three

The Power of Action

CREATION

Action gives birth to our thoughts and feelings
and thus gives meaning to our lives.

Without action, there is no movement,
no change, no progress
and without these, there is no life.

To act on one's beliefs, to create,
to give expression to our creative spirit . . .
this is the true purpose of living.

For even the smallest action — a smile
or a warm embrace — brings joy to others
and thus has meaning and value.

Perhaps, then, it is our duty, our responsibility
to give form to the love in our hearts,
through acts of kindness, generosity, and love.

7

Action

It is belief forged with desire and acted upon with spontaneous, joyful impulse that has the power to change form and events.

It's doing small things for the love of each other — just a smile, or carrying a bucket of water, or showing some simple kindness. These are the small things that make up compassion. . . . It's not how much we give, but how much love we put in the doing — that's compassion in action.

MOTHER TERESA

It is not so much what we have done amiss, as what we have left undone, that will trouble us, looking back.

ELLEN WOOD

I believe we all have the source of truth, the connection to the deepest truth within ourselves, and that we can connect with it by learning to listen to our intuition, to ask for that deepest truth, and to trust and be willing to act on it moment by moment in our lives.

SHAKTI GAWAIN

The bitterest tears shed over graves are for words left unsaid and deeds left undone.

HARRIET BEECHER STOWE

Power comes from living in the present moment, where you can take action and create the future.

SANAYA ROMAN

Of two things fate cannot rob us; namely of choosing the best, and of helping others thus to choose.

MARY BAKER EDDY

In politics, if you want anything said, ask a man; if you want anything done, ask a woman.

MARGARET THATCHER

A measure of frustration is an inevitable accompaniment to endeavor.

ANNA LOUISE STRONG

So much of the satisfying work of life begins as an experiment; having learned this, no experiment is ever quite a failure.

ALICE WALKER
In Search of Our Mothers' Gardens

In a word, I am always busy, which is perhaps the chief reason why I am always well.

ELIZABETH CADY STANTON

To live is to act; to think is to act. But to give is to act with love.

ANONYMOUS

Although nature has proven season in and season out that if the thing that is planted bears at all, it will yield more of itself, there are those who seem certain that if they plant tomato seeds, at harvest time they can reap onions. . . . Too many times for comfort I have expected to reap good when I know I have sown evil. . . . I have not always known that actions can only reproduce themselves, or rather, I have not always allowed myself to be aware of that knowledge.

MAYA ANGELOU

You will do foolish things, but do them with enthusiasm.

COLETTE

One never notices what has been done; one can only see what remains to be done.

MARIE CURIE

Life had taught her that it was not that easy; there are few prepared to fulfill their desires whatever the cost, and the right to determine the course of one's own life would take more effort than she had imagined.

LAURA ESQUIVEL
Like Water for Chocolate

If you don't like the way the world is, you change it. You have an obligation to change it. You just do it one step at a time.

MARION WRIGHT EDLEMAN

No one changes the world who isn't obsessed.

BILLY JEAN KING

I get energy from the earth itself, and I get optimism from the earth itself. I feel that as long as the earth can make a spring every year, I can. As long as the earth can flower and produce nurturing fruit, I can, because I'm the earth. I won't give up until the earth gives up.

ALICE WALKER

It is in vain to say human beings ought to be satisfied with tranquility: they must have action; and they will make it if they cannot find it. Millions are condemned to a stiller doom than mine, and millions are in silent revolt against their lot. Nobody knows how many rebellions besides political rebellions ferment in the masses of life which people earth.

CHARLOTTE BRONTË
Jane Eyre

There is nothing that we have not brought to us either by conscious choice or by unconscious accident. If we are unhappy with the results of our actions, we need to reach a greater understanding of our power.

ANONYMOUS

In soloing — as in other activities — it is far easier to start something than it is to finish it.

AMELIA EARHART

If I can stop one heart from breaking,
I shall not live in vain;
If I can ease one life the aching,
Or cool one pain,
Or help one fainting robin
Into his nest again,
I shall not live in vain.

EMILY DICKINSON

When you cease to make a contribution, you begin to die.

ELEANOR ROOSEVELT

Each of us has a few minutes a day or a few hours a week which we could donate to an old folks' home or a children's hospital ward. The elderly whose pillows we plump or whose water pitchers we refill may or may not thank us for our gift, but the gift is upholding the foundation of the universe. The children to whom we read simple stories may or may not show gratitude, but each boon we give strengthens the pillars of the world.

MAYA ANGELOU

I believe that work is love in action. It is my feeling that if more people thought about their work and their lives in this way, they could accomplish so much and make great strides toward fulfilling their potential.

JEANE PINCKERT DIXON

8

Dreams
& Aspirations

It has been said that "time" does not exist outside
of our perception. If this is true, then as we think,
we create, and as we dream, we manifest, even
though it may appear to "take time." The dream
and the dreamer are present at once; the gift and
the giver are the same One.

Just as each cell contains our whole being, so
each thought and dream contains our whole self,
too. *If our dreams weren't already real within us, we*
could not even dream them.

GLORIA STEINEM

The power that created galaxies, that formed oceans of space, air, water, and consciousness, is the same power that flows through you and beats your heart and gives you consciousness! You have the right to be everything that you are, to know your power, to express and create everything you desire in your heart.

TAE YUN KIM

I do not want to die . . . until I have faithfully made the most of my talent and cultivated the seed that was placed in me until the last small twig has grown.

KÄTHE KOLLWITZ

In my language, "power" means the power to realize our dreams and the Great Spirit that lives within us. One of the first lessons of power is to be able to walk down the path that is presented to us in our lives. Each of us has a path. But we try to change it, thinking, Oh that isn't the way I want to go; I want to go this way. Or we make many choices out of ignorance, which leads us away from the trail home.

LYNN ANDREWS

To love what you do and feel that it matters —
how could anything be more fun?

KATHARINE GRAHAM

There were many ways of breaking a heart. Sto-
ries were full of hearts broken by love, but what
really broke a heart was taking away its dream —
whatever that dream might be.

PEARL S. BUCK

Far away there in the sunshine are my highest
aspirations. I may not reach them, but I can look
up and see their beauty, believe in them, and try
to follow where they lead.

LOUISA MAY ALCOTT

A number two pencil and a dream can take you
anywhere.

JOYCE A. MYERS

I don't have problems. I only have desires that
I've not yet learned to create and fears that I've
not yet learned to release.

ANONYMOUS

One can never consent to creep when one feels an impulse to soar.

HELEN KELLER

The truth is that, like every other part of nature, human beings have an internal imperative to grow.

GLORIA STEINEM

Woman must not accept; she must challenge. She must not be awed by that which has been built up around her; she must reverence that woman in her which struggles for expression.

MARGARET SANGER

Only when men are connected to large universal goals are they really happy — and one result of their happiness is a rush of creative activity.

JOYCE CAROL OATES

The future belongs to those who believe in the beauty of their dreams.

ELEANOR ROOSEVELT

To fall in love is very easy, even to remain in it is not difficult; our human loneliness is cause enough. But it is a hard quest worth making to find a comrade through whose presence one becomes steadily the person one desires to be.

ANNA LOUISE STRONG

Rebuffed, but always persevering; self-reproached, but ever regaining faith; undaunted, tenacious, the heart of man labors toward immeasurably distant goals.

HELEN KELLER

9

Passion & Purpose

I have heard so many women question the meaning of their lives and wonder what they can do with their passion. I have come to believe there is only one answer: Be Love in all of its forms and manifestations, live with love in your heart to the best of your ability, and you will always know what to do.

Religion has nothing to do with compassion; it is our love for God that is the main thing because we have all been created for the sole purpose to love and be loved.

MOTHER TERESA

Many of the things we are guided to do in our lives may not *seem* to have a direct connection with helping anyone or healing the world. . . . The greatest contribution that you can make is in the aliveness that comes from simply being yourself, living your truth, and doing what you love. The passionate expression of who we are will heal the world.

SHAKTI GAWAIN

In every sacred moment there is a sense of timelessness and wholeness, of having a place in the Universe, of mattering, which I have experienced as both a revelation and a confirmation of something familiar, somehow already known, even as I may experience it consciously for the first time. . . . I respond to the grace I feel with gratitude and a commitment to live by what I intuitively and experientially know to be true for me.

JEAN SHINODA BOLEN

Learn to get in touch with silence within yourself and know that everything in this life has a

purpose. There are no mistakes, no coincidences, all events are blessings given to us to learn from.

ELISABETH KÜBLER-ROSS

Every human being has some handle by which he may be lifted, some groove in which he was meant to run; and the great work of life, as far as our relations with each other are concerned, is to lift each one by his own proper handle and run each one in his own proper groove.

HARRIET BEECHER STOWE

In her instinctual psyche, a woman has the power, when provoked, to be angry in a mindful way — and that *is* powerful. Anger is one of her innate ways to begin to reach out to create and preserve the balances that she holds dear, all that she truly loves. . . . It is both her right, and at certain times and in certain circumstances, a moral duty.

CLARISSA PINKOLA ESTÉS

The steam rising from the pan mingled with the heat given off by Tita's body. The anger she felt

within her acted like yeast on bread dough. She felt its rapid rising, flowing into every last recess of her body; like yeast in a small bowl, it spilled over to the outside, escaping in the form of steam through her ears, nose, and all her pores.

LAURA ESQUIVEL
Like Water for Chocolate

I believe that what woman resents is not so much giving herself in pieces as giving herself purposelessly. . . . Purposeful giving is not as apt to deplete one's resources; it belongs to that natural order of giving that seems to renew itself even in the act of depletion. The more one gives, the more one has to give. . . .

ANNE MORROW LINDBERGH

It has always been my belief that we are all here for a specific purpose, gifted with various talents, and that we have an obligation to the Being who entrusted us with those gifts to develop them to our maximum ability.

JEANE PINCKERT DIXON

Pride is faith in the idea that God had when he made us. . . . As the good citizen finds his happiness in the fulfillment of his duty to the community, so does the proud man find his happiness in the fulfillment of his fate.

ISAK DINESEN
Out of Africa

[My whole life was] devoted unreservedly to the service of my sex. The study and practice of medicine is, in my thought, but one means to a great end, for which my very soul yearns with intensest passionate emotion . . . the true ennoblement of woman, the full harmonious development of her unknown nature, and the consequent redemption of the whole human race.

DR. ELIZABETH BLACKWELL

My life has been joyous and exulting and full because it has touched profoundly millions of other lives. It is ever a privilege to be a part of something unquestionably proved of value, something so fundamentally right. . . .

MARGARET SANGER

It is the denial of death that is partially responsible for people living empty, purposeless lives; for when you live as if you'll live forever, it becomes too easy to postpone the things you know that you must do. You live your life in preparation for tomorrow or in remembrance of yesterday, and meanwhile, each today is lost. In contrast, when you fully understand that each day you awaken could be the last you have, you take the time *that day* to grow, to become more of who you really are, to reach out to other human beings.

ELISABETH KÜBLER-ROSS

My grandmother had a very interesting theory; she said that each of us is born with a box of matches inside us but we can't strike them all by ourselves . . . we need oxygen and a candle to help. In this case, the oxygen, for example, would come from the breath of the person you love; the candle could be any kind of food, music, caress, word, or sound that engenders the explosion that lights one of the matches. For a moment we are dazzled by an intense emotion.

A pleasant warmth grows within us, fading slowly as time goes by, until a new explosion comes along to revive it. Each person has to discover what will set off those explosions in order to live, since the combustion that occurs when one of them is ignited is what nourishes the soul. That fire, in short, is its food. If one doesn't find out in time what will set off these explosions, the box of matches dampens, and not a single match will ever be lighted.

LAURA ESQUIVEL
Like Water for Chocolate

Nothing in life is trivial. Life is whole wherever and whenever we touch it, and one moment or event is not less sacred than another.

VIMALA THAKAR

May each member of this church rise above the oft-repeated inquiry, What am I? to the scientific response: I am able to impart truth, health, and happiness, and this is my rock of salvation and my reason for existing.

MARY BAKER EDDY

Every person has a purpose and a reason for being on earth.

SANAYA ROMAN

No matter what, I want to continue living with the awareness that I will die. Without that, I am not alive. That is what makes my life possible.

BANANA YOSHIMOTO
Kitchen

You are a being unlimited by nature, born into flesh to materialize as best you can the great joy and spontaneity of your nature. . . . Your spirit joined itself with flesh, and in flesh, to experience a world of incredible richness, to help create a dimension of reality of colors and of form. . . . You are here to use, enjoy, and express yourself through the body. You are here to aid in the great expansion of consciousness. You are not here to cry about the miseries of the human condition, but to change them when you find them not to your liking through the joy, strength and vitality that is within you; to create the spirit as faithfully and beautifully as you can in flesh.

JANE ROBERTS

About the Editor

Janet Mills is Chief Executive Officer and Senior Editor of New World Library, and the author of *Free of Dieting Forever,* published by Warner Books. She is a magna cum laude graduate of the University of Pittsburgh with a Bachelor of Arts degree in education and psychology. Born in Pennsylvania and raised in several states, she moved to San Francisco in 1982 and currently makes her home in Marin County, California.

Bibliographic Index

The information in this index allows the reader to locate the contributions of authors within the text and to further explore their writing. Applicable publisher permissions and copyright notices follow the index.

Permissions

Grateful acknowledgment is made to the following for permission to reprint excerpts from previously published material:

THE CLASSIC WISDOM COLLECTION

AS YOU THINK by James Allen.

NATIVE AMERICAN WISDOM. Edited by Kent Nerburn and Louise Mengelkoch.

THE ART OF TRUE HEALING by Israel Regardie.

LETTERS TO A YOUNG POET by Rainer Maria Rilke.

THE GREEN THOREAU. Edited by Carol Spenard LaRusso.

POLITICAL TALES & TRUTH OF MARK TWAIN. Edited by David Hodge and Stacey Freeman.

THE WISDOM OF WOMEN. Edited by Carol Spenard LaRusso.

THE SOUL OF AN INDIAN AND OTHER WRITINGS FROM OHIYESA. Edited by Kent Nerburn.

AFRICAN AMERICAN WISDOM. Edited by Reginald McKnight.

THE WISDOM OF THE GREAT CHIEFS. Edited by Kent Nerburn.

THE POWER OF A WOMAN. Edited by Janet Mills.

If you would like a catalog of our fine
books and cassettes, contact:

New World Library
58 Paul Drive
San Rafael, CA 94903

Or call toll free: (800) 227-3900